中 國 名 家 繪 畫
PAINTINGS BY CHINESE MASTERS

清 代 卷
QING DYNASTY
I

清 代 卷

中國書店
CATHAY BOOKSHOP

中國名家繪畫60卷目録
TITLES OF 60 VOLUMES OF *PAINTINGS* BY *CHINESE MASTERS*

畫家簡介

王時敏（1592－1680）

字遜之、號煙客、西廬老人等，江蘇太倉人。

王　鑒（1598－1677）

字圓照、號湘碧、染香庵主等，江蘇太倉人。

程正揆（1604－1670）

字端伯、號鞠陵、青谿縣道人等，湖北孝感人。

漸　江（1610－1663）

俗姓江，名韜、舫，字六奇，爲僧後名弘仁，號漸江學人、漸江僧、梅花古衲等，安徽歙縣人。

髡　殘（1612－1673）

俗姓劉，字石谿，號白禿、殘道者、電住道人、名道人等，湖南武陵（今常德）人。

查士標（1615－1698）

字二瞻，號梅壑、梅壑散人、後乙卯生等，安徽海陽人。

龔　賢（1618－1689）

又名豈賢，字半千、號半畝、柴丈人等，江蘇崑山人。

戴本孝（1621－1693）

字務旃，號前休子、鷹阿山樵等，安徽休寧人。

梅　清（1623－1697）

原名士羲，字淵公，號瞿山、梅痴、雪廬、柏梘山人等，安徽宣城人。

祝　昌（？－？）

字山嘲，安徽廣德人（一作安徽舒城人）。

BIOGRAPHIES OF PAINTERS

Wang Shimin (1592 – 1680)

A native of Taicang, Jiangsu Province, his other names are Xunzhi, Yanke, and Xilulaoren.

Wang Jian (1598 – 1677)

A native of Taicang, Jiangsu Province, he is also known as Yuanzhao, Xiangbi and Ranxiang'anzhu.

Cheng Zhengkui (1604 – 1670)

Born in Xiaogan, Hubei Province, his other names are Duanbo, Juling and Qingshexiandaoren.

Jian Jiang (1610 – 1663)

A native of She County, Anhui Province, his lay names are Jiang Tao and Jiang Fang, and his other name is Liuqi. After he became a monk, he took on other names: Hongren, Jianjiangxueren, Jianjiangseng, and Meihua guna.

Kun Can (1612 – 1673)

A native of Wuling (present-day Changde), Hunan Province, his lay surname was Liu. His other names are Shixi, Baitu, Candaozhe, Dianzhudaoren, and Mingdaoren.

Zha Shibiao (1615 – 1698)

A native of Haiyang, Anhui Province, his other names are Erzhan, Meihe, Meihesanren, and Houyimaosheng.

Gong Xian (1618 – 1689)

A native of Kunshan, Jiangsu Province, his other names are Qixian, Banqian, Banmu, and Chaizhangren.

Dai Benxiao (1621 – 1693)

Born in Xiuning, Anhui Province, his other names are Wu Zhan, Qianxiuzi, and Ying'ashanqiao.

Mei Qing (1623 – 1697)

A native of Xuan Cheng, Anhui Province, his original name was Shixi, but is also known as Yuangong, Qushan, Meichi, Xuelu and Bojianshanren.

Zhu Chang (? – ?)

A native of Guangde, Anhui Province (also believed to be from Shucheng in Anhui), his other name is Shanchao.

序

況　達

當今，世界已處在全球經濟一體化的進程中，未來是否還會出現對政治一體化的尋求？我們不得而知。但果真如此時，地球那倒真是一個“村”的概念了。

相對於國界的明確，不同國度、不同民族間的文化界綫就模糊得多。這一方面出於人類精神的某些共通性，另一方面也是出於完善和發展自己的自覺。人們之間的相互了解、理解與借鑒，早在具有明確的群體及組織之前就已開始了。

作爲文化高端的繪畫藝術，其形式凝結着一個民族與生俱來的精神信息和審美情結，表現着人類的普遍性，也表現着人類對“現實”和“理想”、“已知”和“未來”的種種思考與困惑。正是由於人類的這些共通性之所在，繪畫藝術就成了無須翻譯便可交流的文化形式。

有記載的中國的繪畫可追溯到三千年以上。戰國時期（前475—前221）就已有專業的畫家（時稱“畫史”）。中國畫重精神，藝必合於道，是爲精神。故傳統上連稱“道藝”，又曰“心畫”，要求性情的真（“自然”—自然而然）與人性向上（以臻於“至善”。而不以“自我”爲中心）。也許是由於中國先民理智（人之所以爲人）之早熟；再，或許是最先導入繪畫之工具的特殊性，使中國繪畫由人類繪畫之初點、綫的普遍形式，到了東晉（317—420）進而演化成爲以點、畫爲“骨法”的藝術形式（“筆墨”爲畫的實體），確定了其不同凡響的特殊面目和特殊精神，也就是因爲這種特質，使它成爲世界繪畫的一個高峰。

繪畫藝術的屬性是什麼？從中國古代藝術家大量論及藝術及藝術功能的觀點中可知：藝術不止於近代所説的“審美”，亦不應祇是今天人們所説的“自娛”或“娛人”，似乎在“悦情”與“快人意”之外，還應關注自然與生命、人生與社會，所謂“成教化，助人倫，窮神變，測幽微”，所謂成己、成人、成物即是。從深層上説，不論在東方還是在西方，藝術品之所以被人們所喜愛，藝術家之所以被社會所尊重，多是由於這個原因。因爲，社會没有理由去尊重一個對人生以及由衆多人生構成的社會既無熱情、也無作爲的人。

爲了使當今世界了解中國繪畫，也爲這種具有獨特藝術精神與形式語言的繪畫藝術達到審美共享，我們確定了這套名家繪畫的編選原則，即所選畫家一定要具有時代之代表性，所選作品一定要具有畫家藝術風格之代表性。

所謂名家，是指在中國畫藝術領域中卓有成就的畫家，他們有傳有承，技有創新並形成自己面目者；至於在筆墨形式、精神境界均有獨創性之成就，則可謂大家者也。此，均與資歷、資格及社會職位等因素無涉。

所謂名作，就中國畫而言，則是指那些藝術創造信息密集、能“筆境兼奪”、具有絶對藝術之高度的繪畫作品。

本輯《中國名家繪畫》所選戰國至清代時期的作品，亦基於以上之觀點。

此輯之作品，是從戰國時期至清代末衆多杰出的畫家及其作品中遴選出來的具有經典意義的精作佳構。

同時，爲使西方藝術家及藝術鑒賞家第一時段就能全面、立體的理解、認識中國繪畫的純粹美與精華，我們又將歷代繪畫理論中具有代表性的畫論精華輯録在側。

對這些藝術作品的欣賞，用得上中國獨特的審美方式：品味，因爲藴含在這些作品中的形式美與境界美，絶非是以走馬觀花式的匆忙所能獲得的。

PREFACE

Kuang Da

The world is in the process of a global economic integration. I do not know whether there will be a political integration in the future, but if it does happen, the world will indeed become one "village". Compared to clear-cut national boundaries, however, cultural boundaries between different nations and different ethnic groups will become much more blurred. This might be because of certain commonalities in human nature, but it is also because of people's conscious initiatives to improve and develop themselves. People began trying to understand and comprehend each other and learn from each other even before they had any explicit sense of community or organization.

The art of painting, which is a supreme cultural form of expression, embodies a nation's inherent spirit and aesthetic taste, and expresses human thoughts and perplexities about "realities" and "ideals", and "known" and "unknown" worlds. It is precisely due to the existence of this common human nature that painting as an art form can communicate across cultures without need of translation.

According to existing records, Chinese painting dates back more than 3000 years. In the Warring States period (475 B.C. – 221 B.C.), there were already professional artists called "painter historians". Chinese painting puts more emphasis on spirit. Art must be in accord with the principles of Nature, and that is spirit. Therefore, traditionally it is called "principled art" which is also called "painting from the heart", and this requires embodying the true nature of humanity and the human tendency to seek improvement. This should even extend to the greatest good, but it should not be self-centered. It may have been the ancient Chinese people's early maturity of intellect which defines humanity, or perhaps it was the special nature of the earliest tools introduced to them, that enabled Chinese painting to start with the use of dots and lines common to peoples around the world. This evolved into the so-called "brush stroke method" (using the brush pen and black ink) of using dots in the Eastern Jin (317 – 420), afirming its unique appearance and spirit. It is also this unique quality that has made Chinese painting a pinnacle in world painting.

What are the main properties of the art of painting? When ancient Chinese artists talk about the function of painting, they believe that art is more than "esthetics" of modern times, it should also be more than self-amusement or entertaining others as said by contemporaries today. Beyond "pleasing the senses" and "pleasing people", painting should concern itself with nature and life, and with living and society. In other words, painting should "enlighten people, improve human relations, and express spiritual essence while exploring the mysteries of the universe". This means fully developing oneself, fully developing others and fully developing all things. This is the very reason why artistic works are loved and artists are respected both in the West and in the East. There is no reason why society should respect a person who is not passionate about life and society, and makes no contribution to society.

In order that today's world may better understand Chinese painting and share in the aesthetic pleasures of its unique spirit and form, we have compiled these volumes of paintings by Chinese masters based on the principle of artists representing their times and their works representing the style of the artists.

What is meant by "masters" here is those artists who have made great achievements in the realm of Chinese painting. They have inherited tradition and brought out new ideas. They have shown innovative skills and formed their own identity to the extent that they reveal their own unique creativity, and can be called great artists or masters. It has nothing to do with their experience, qualifications or social status.

What is meant by master works, as far as Chinese painting is concerned, are those which are loaded with creative information, and excel both in brushwork and artistic realm, with a high degree of absolute artistic achievement.

This series of works selected from the Warring States Period to the end of the Qing Dynasty in *Paintings By Chinese Masters* is based on the above views. The works in this series are classic works selected from among the numerous excellent artists and their works.

At the same time, in order to allow Western artists and connoisseurs to more completely and solidly appreciate Chinese artists and their paintings on first contact, and come to understand and accept the pure simplicity and essence of Chinese painting, we have also compiled and appended each artist's representative views on painting.

To appreciate these works, we may use the unique Chinese way of appreciation called "savoring". The beauty of form and the beauty of artistic realms embodied in these works simply cannot be appreciated by going through them in haste.

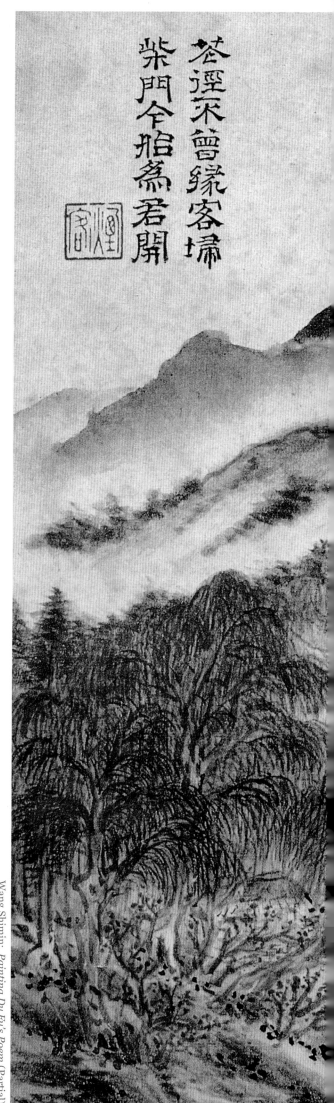

蒼逕不曾緣客掃
柴門今始為君開

Wang Shimin: *Painting Du Fu's Poem* (Partial)

王時敏　杜甫詩意圖 （局部）

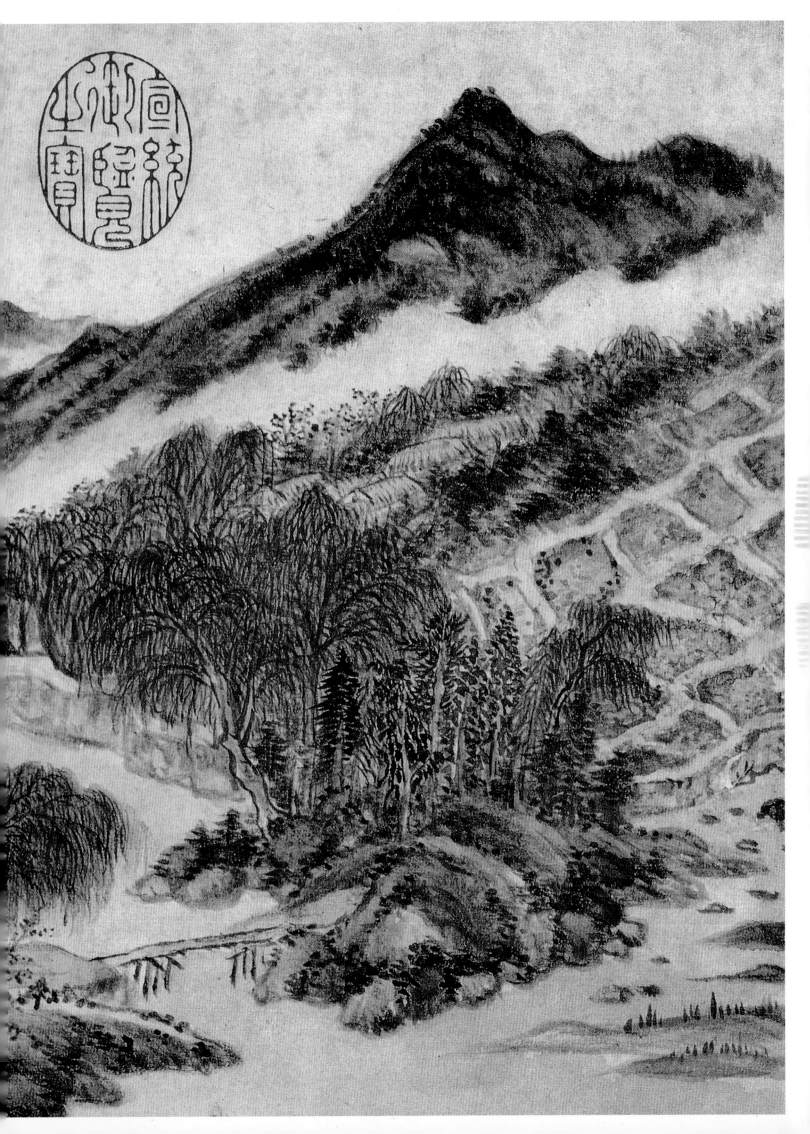

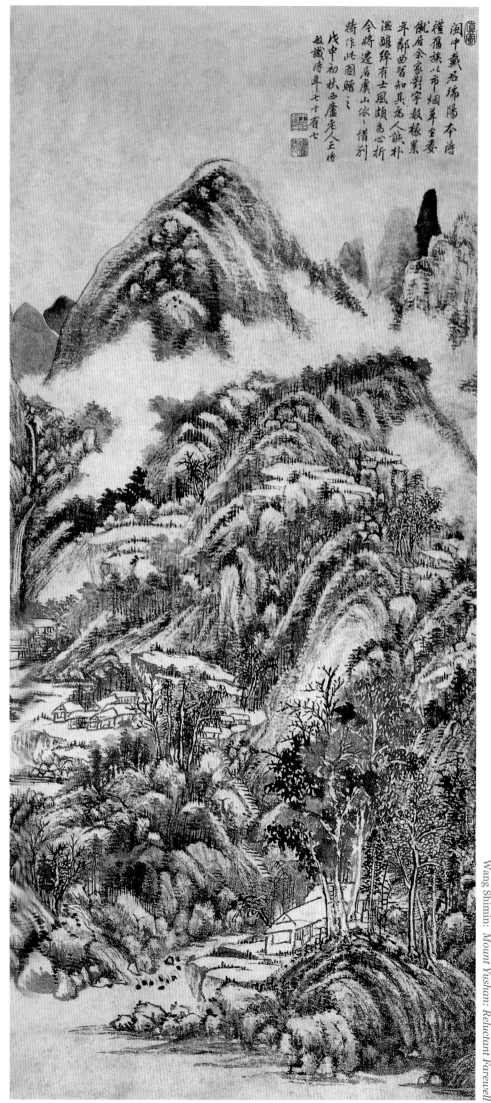

闽中戴名瑞阳本诗
襁褓族此市烟草垒委
俄后余家对字数椒果
年郡曲者知其高人诚朴
溪头绰有士风颇为心折
今将遗后虞山依此惜别
持作此图赠之
戊申初秋西庐老人王时
敬识时年七十有七

王時敏　虞山惜別圖
134×60.2 cm

Wang Shimin: Mount Yushan: Reluctant Farewell

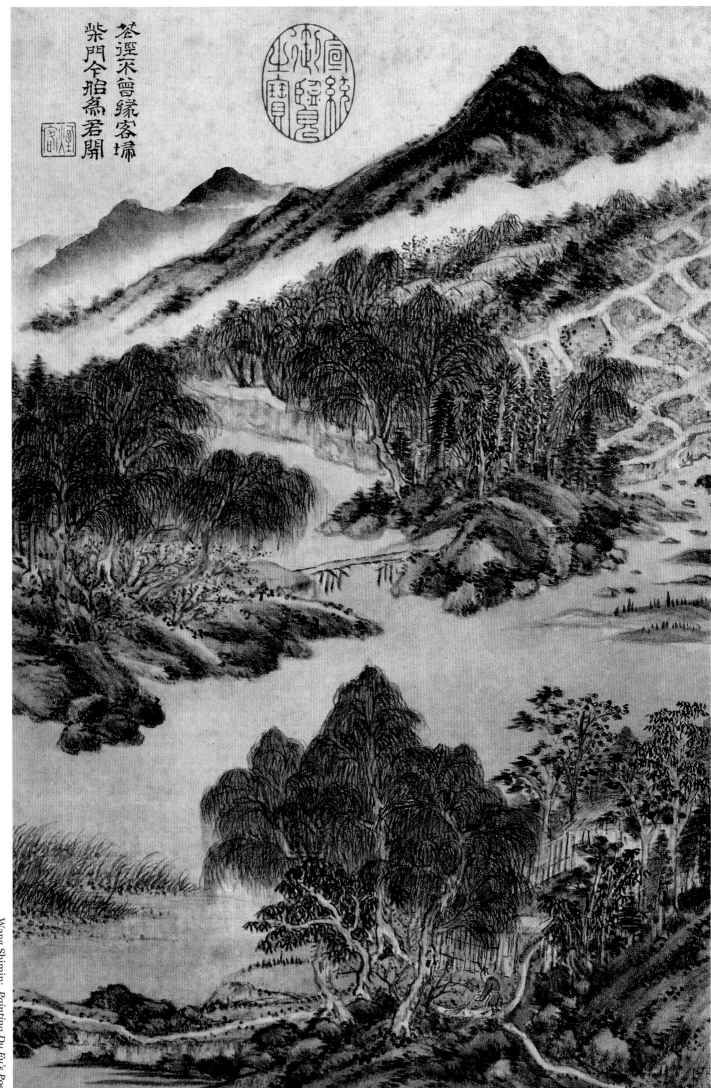

茶逕不曾緣客掃
柴門今始為君開

Wang Shimin: *Painting Du Fu's Poem*
39×25.5 cm

王時敏　杜甫詩意圖

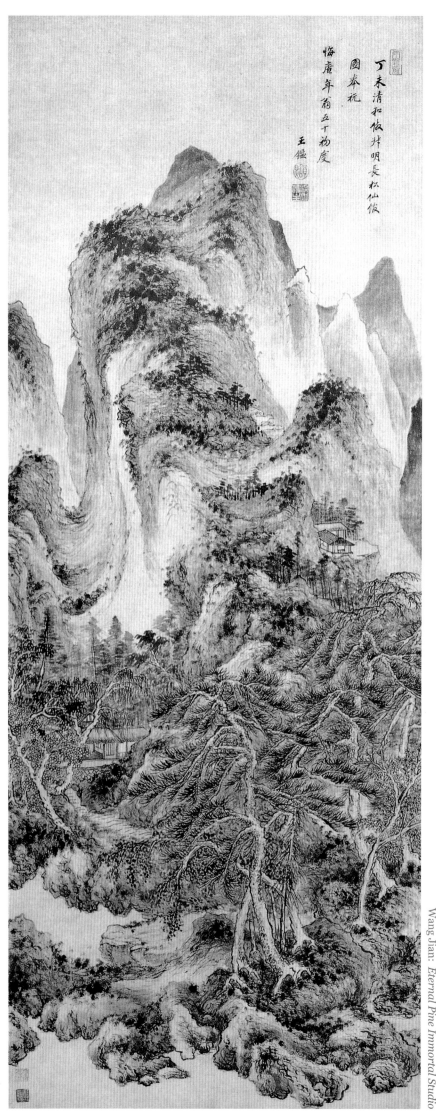

丁未清和倣并明長松仙館
圖奉祝
悔菴年翁五丁初度
王鑑

王鑒　長松仙館
138.5×54.6 cm
Wang Jian: *Eternal Pine Immortal Studio*

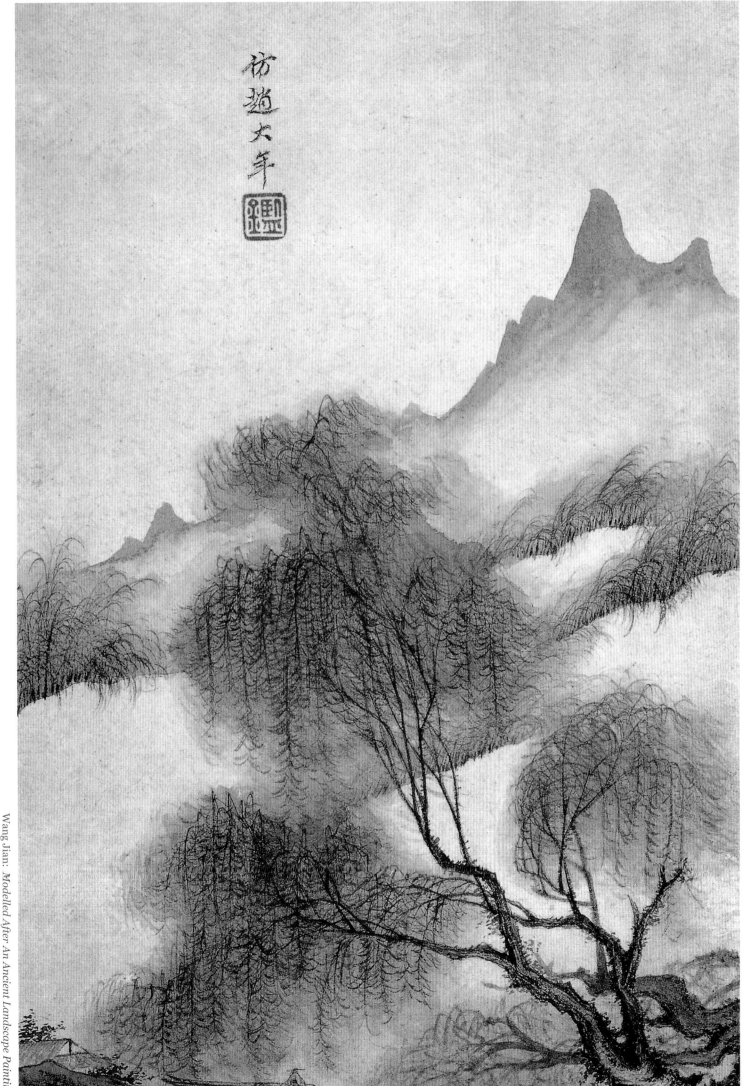

仿趙大年

王鑑　仿古山水圖

王鑑　仿古山水圖

Wang Jian: *Modelled After An Ancient Landscape Painting*

27×18.3 cm

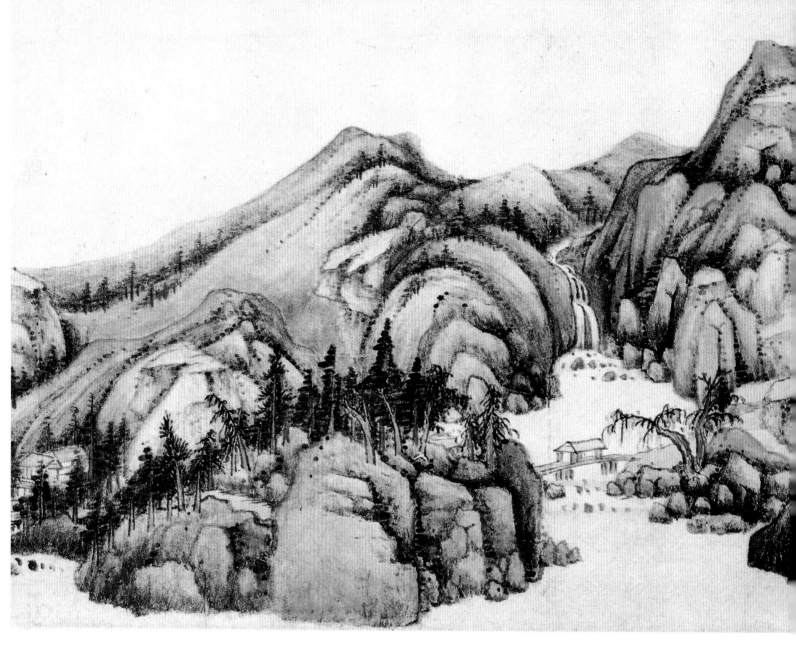

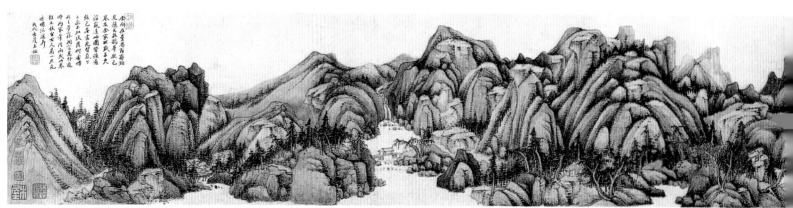

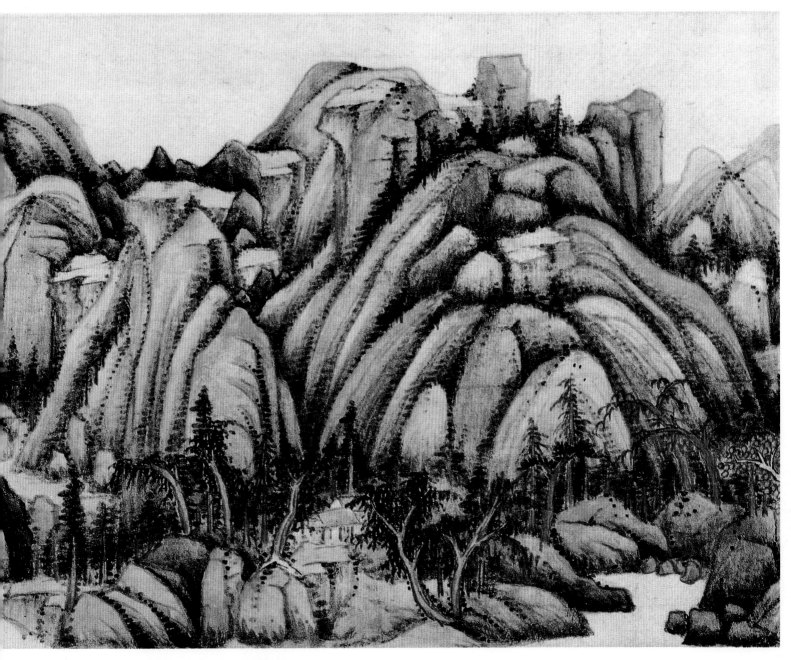

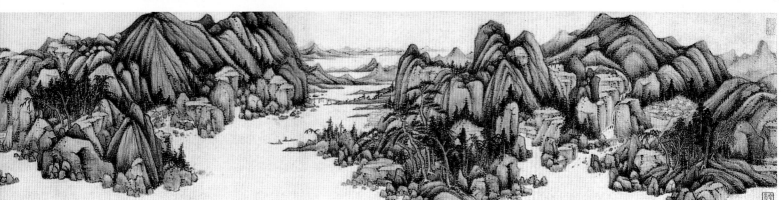

Wang Jian: *Landscape Scroll in Blue and Green*
22.8×199.2 cm
王鑒　青綠山水卷

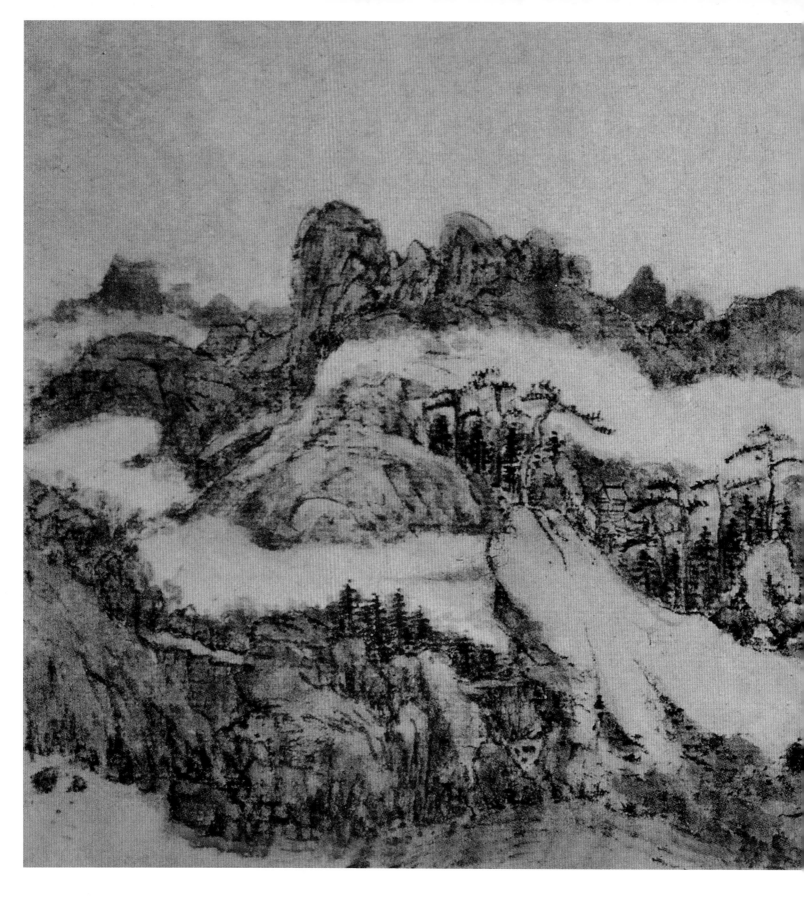

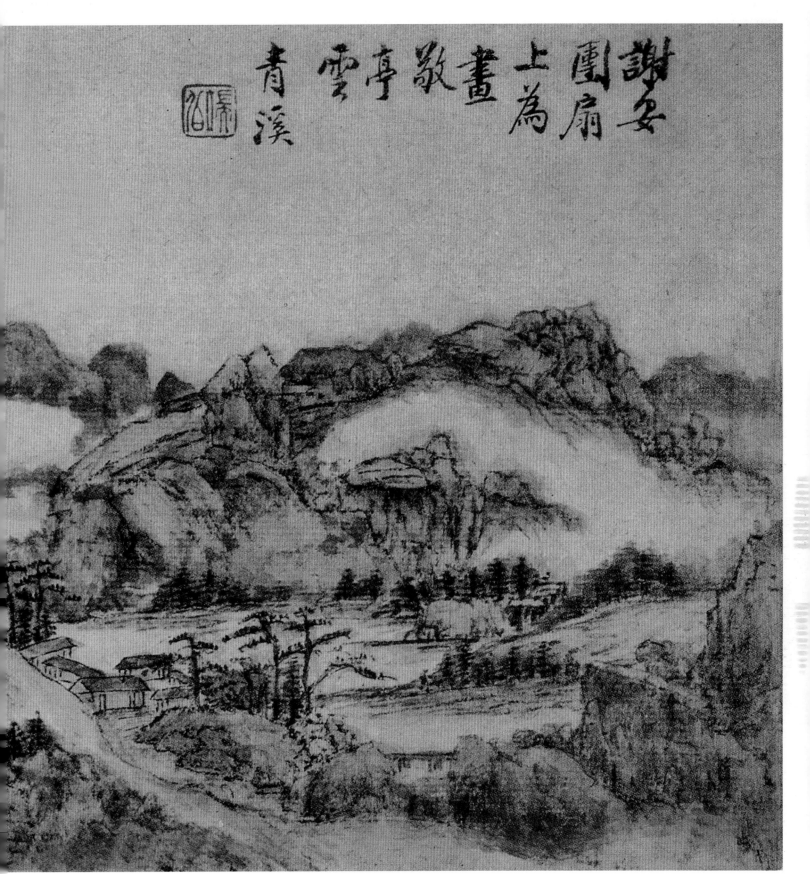

謝安團扇上為畫敬亭雲青溪

Cheng Zhengkui; *Landscape*
22.7×44.3 cm
程正揆　山水册

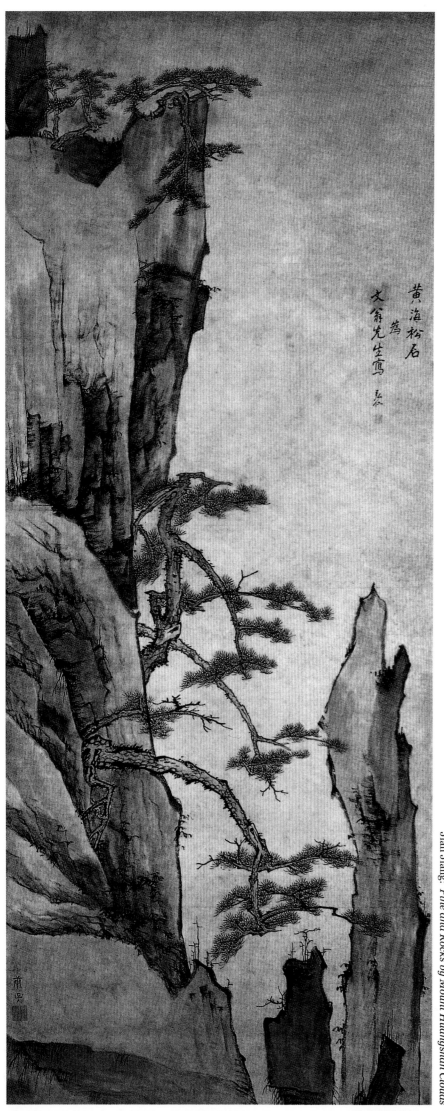

黄海松石

文翁先生寫

爲

漸江 黄海松石
198.7×81 cm
Jian Jiang: *Pine and Rocks by Mount Huangshan Clouds*

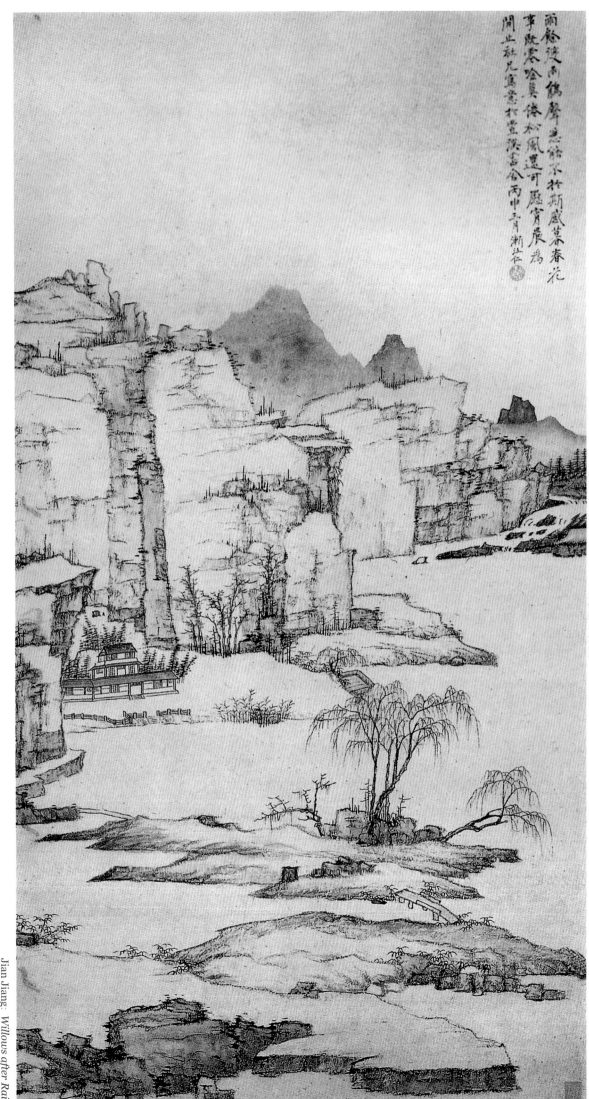

雨餘後兩髻鬆无飴水於斯感暮春花
事晼寒哈真係松風遼可題宵展為
閒止社兄寫意於豐溪畫合丙申三月漸江

Jian Jiang: *Willows after Rain*
84.4×45.3 cm

漸江　雨餘柳色圖

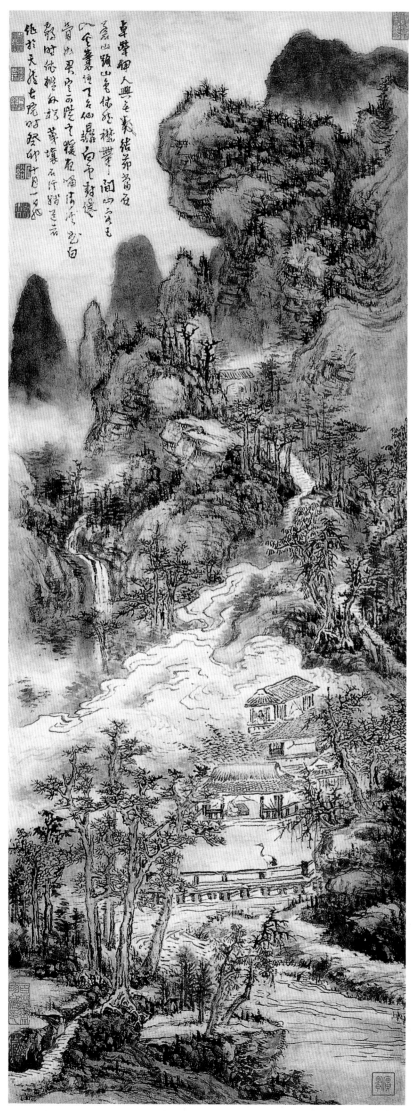

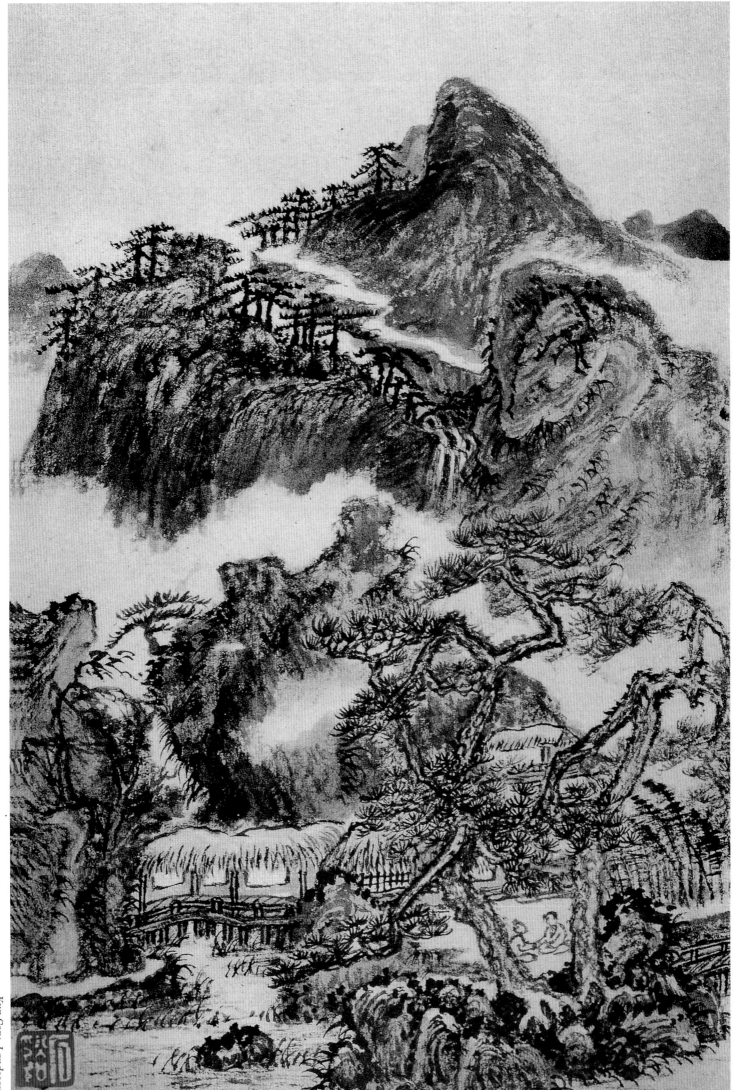

Kun Can: *Landscape*
22.8 ×15.3 cm

髡殘　山水册

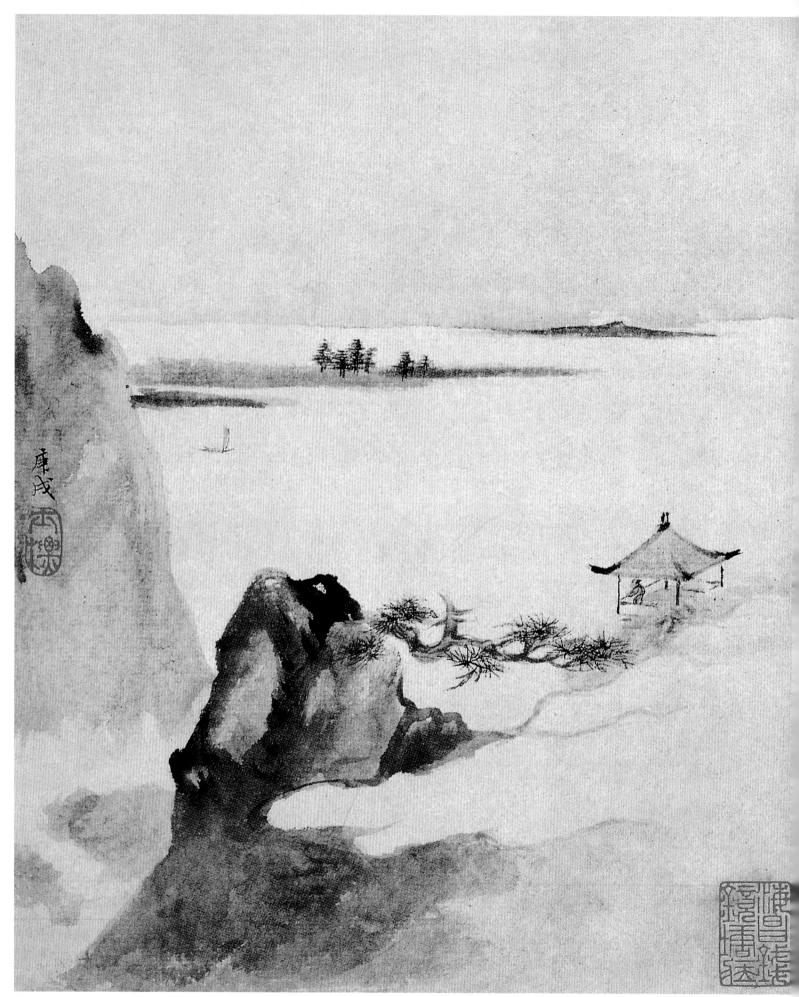

Zha Shibiao: *Painting of One Enjoying the Scenery*
18.7×15.4 cm
查士標　書畫自賞圖

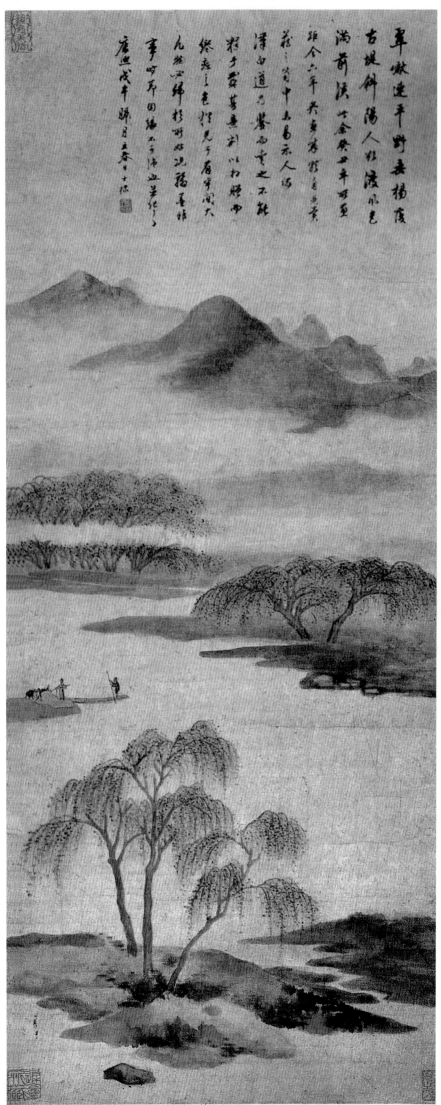

群嶂连平野无桥渡
古堤斜阳人歌渡水光
满前渓 七金葵丑年可至
距今六年夹亥冬柞自兄弟
荘二岁中五首元人词
涤白道乃誊西堂之不能
秋声葛葛无刻以扣歌肿
怂速之老作先于暮宇成大
事坪所闭宿二之浦立英作子
虞然戊午瞬日二春
　　　　　　　　士標

Zha Shibiao: Landscape

90.1×36.7 cm

查士標　山水圖

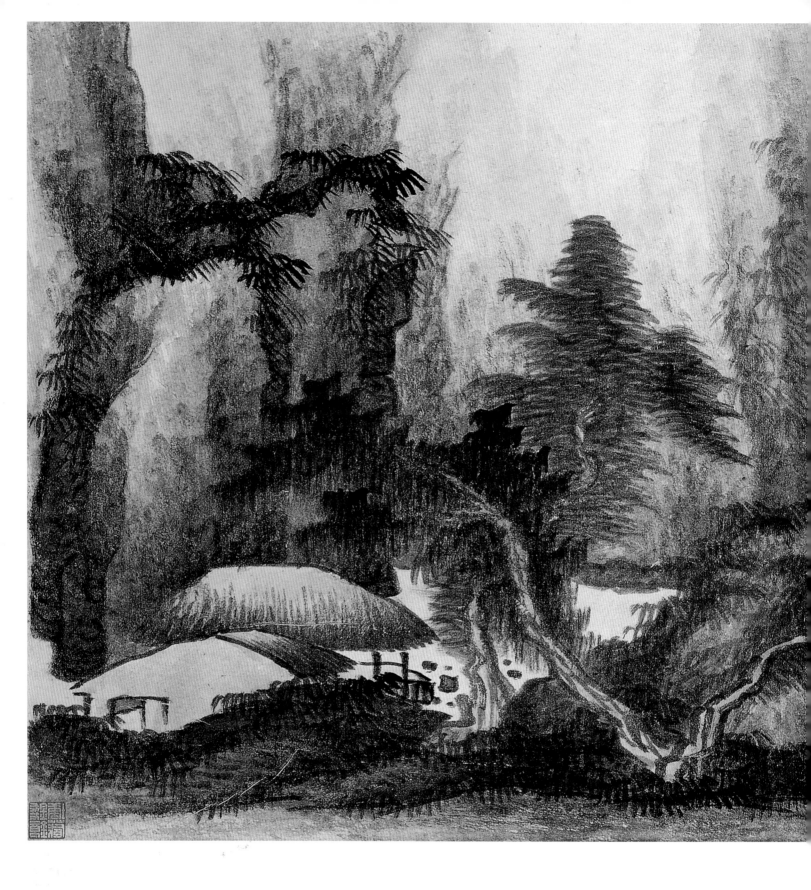

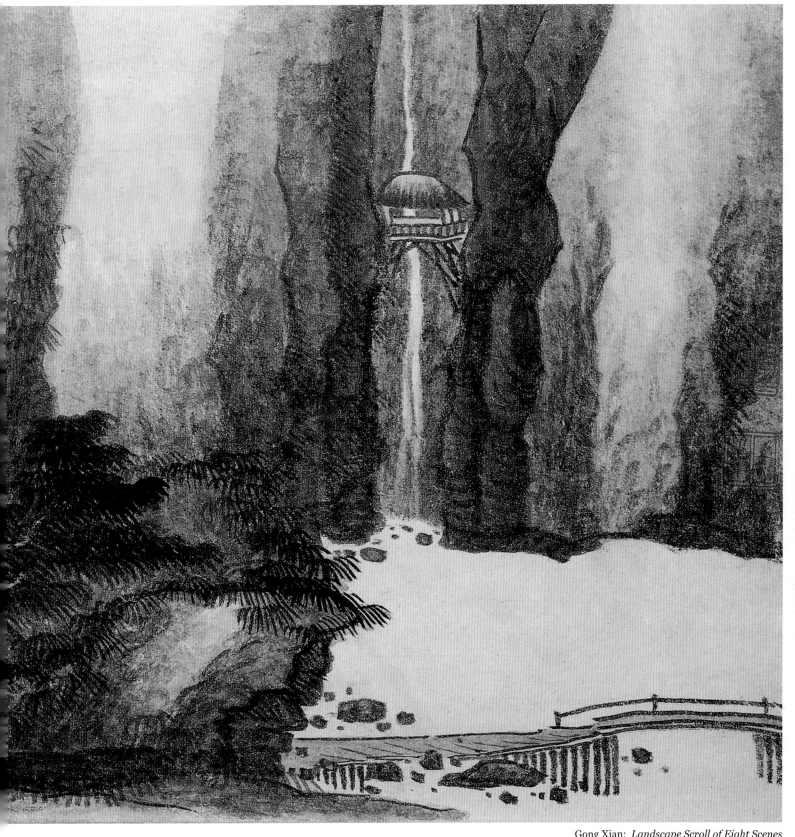

Gong Xian: *Landscape Scroll of Eight Scenes*
24.4×49.7 cm

龔賢　八景山水圖

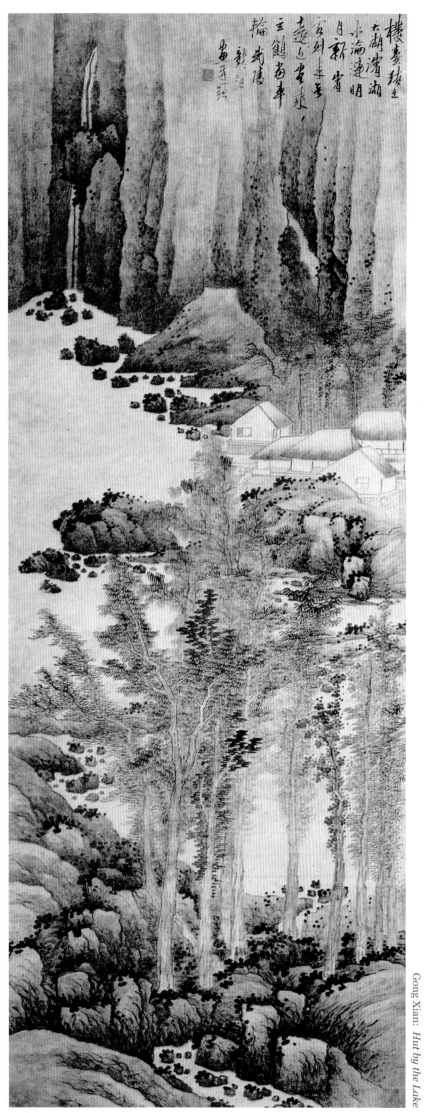

樓臺珠玉立
太湖濱湖
水淪連明
月新省
宿到年年
遠上畫遲
三鶴南車
輪武陵
新湖
莆葦一詩

龔賢 湖濱草閣圖
218×82.8 cm
Gong Xian: *Hut by the Lake*

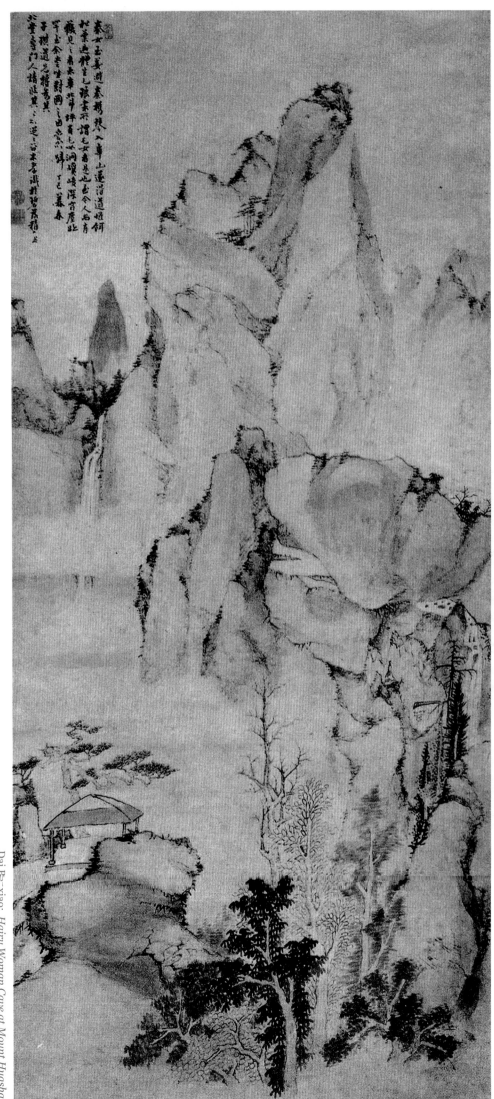

毛女玉姜遊秦為鸞翼人華山遂得道姓餅
此葉華得之毛女畫此今人名有
飲見之康來華非得有此洞壞深奇應此
下上令寺洞對圖之由忽然歸乙巳暮春
古測道之榜高其
子孝春門人楊旭真乙逆二古本考戴村智芳稽上

Dai Ben-xiao: *Hairy Woman Cave at Mount Huashan*

137.5×63.1 cm

戴本孝　華山毛女洞圖

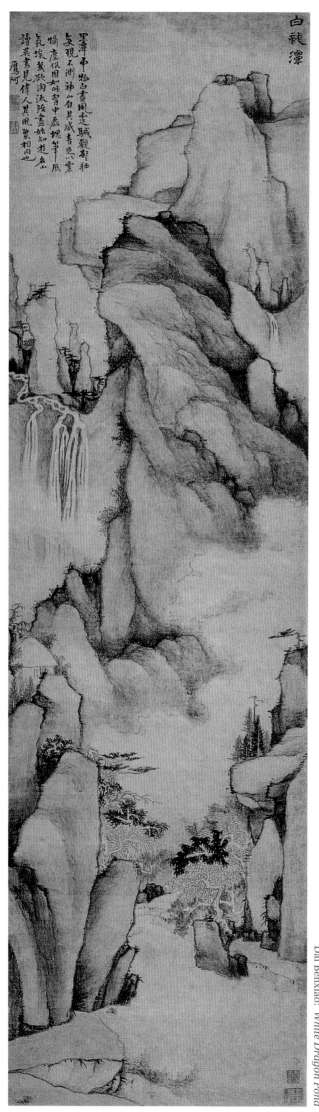

戴本孝　白龍潭

189.3×53.9 cm

Dai Benxiao: *White Dragon Pond*

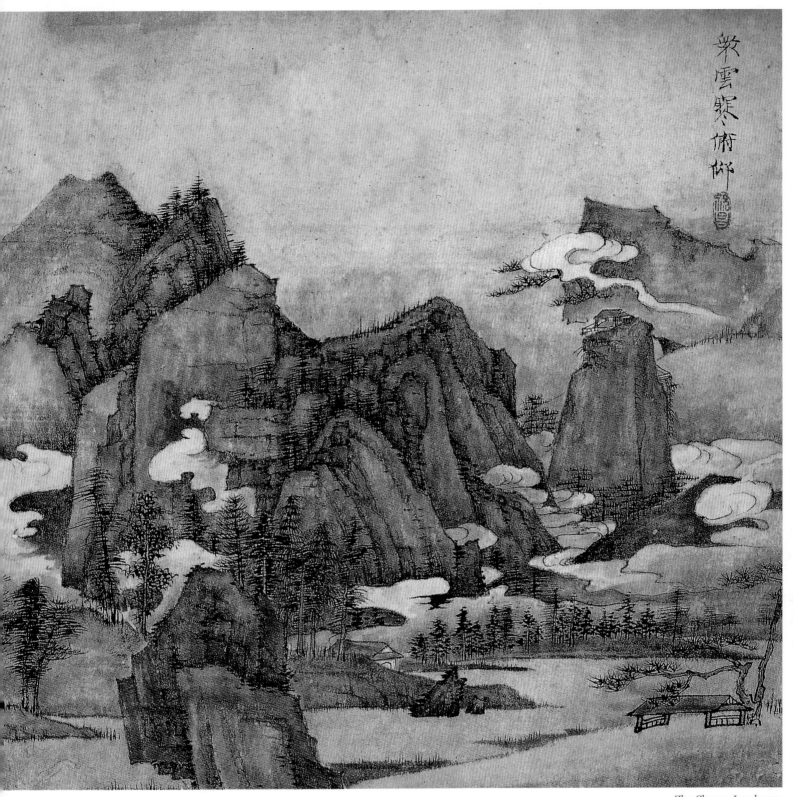

敢雲縱術街

Zhu Chang: *Landscape*
21.5×22.2 cm
祝昌　山水圖

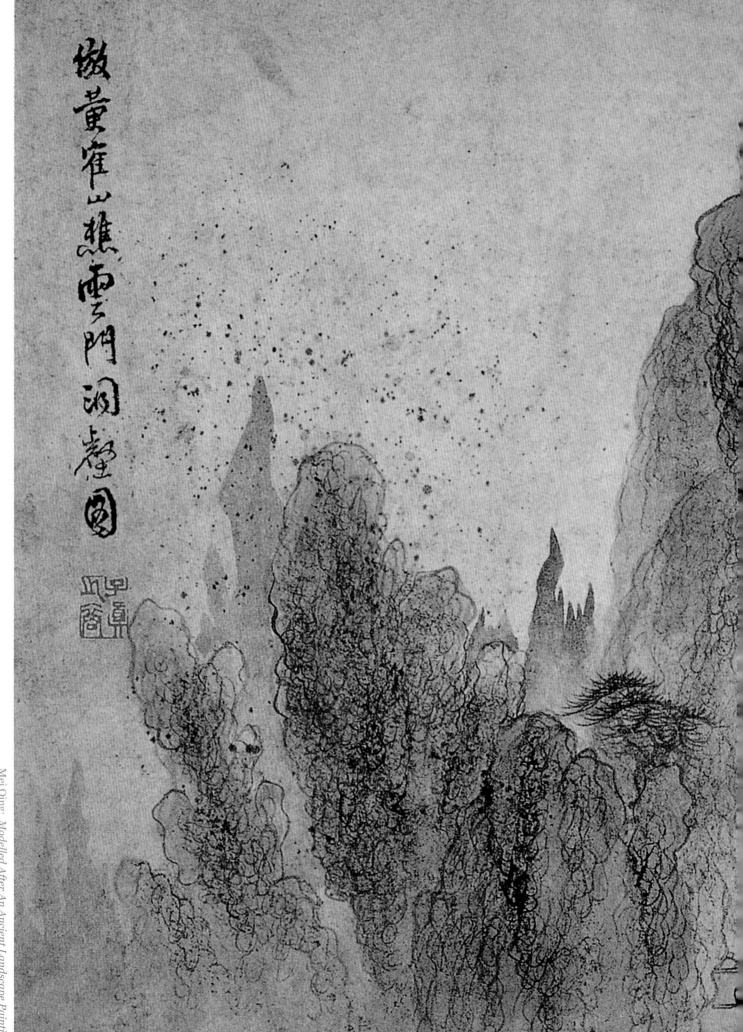

Mei Qing: *Modelled After An Ancient Landscape Painting*

30.3×45.5 cm

梅清　仿古山水圖

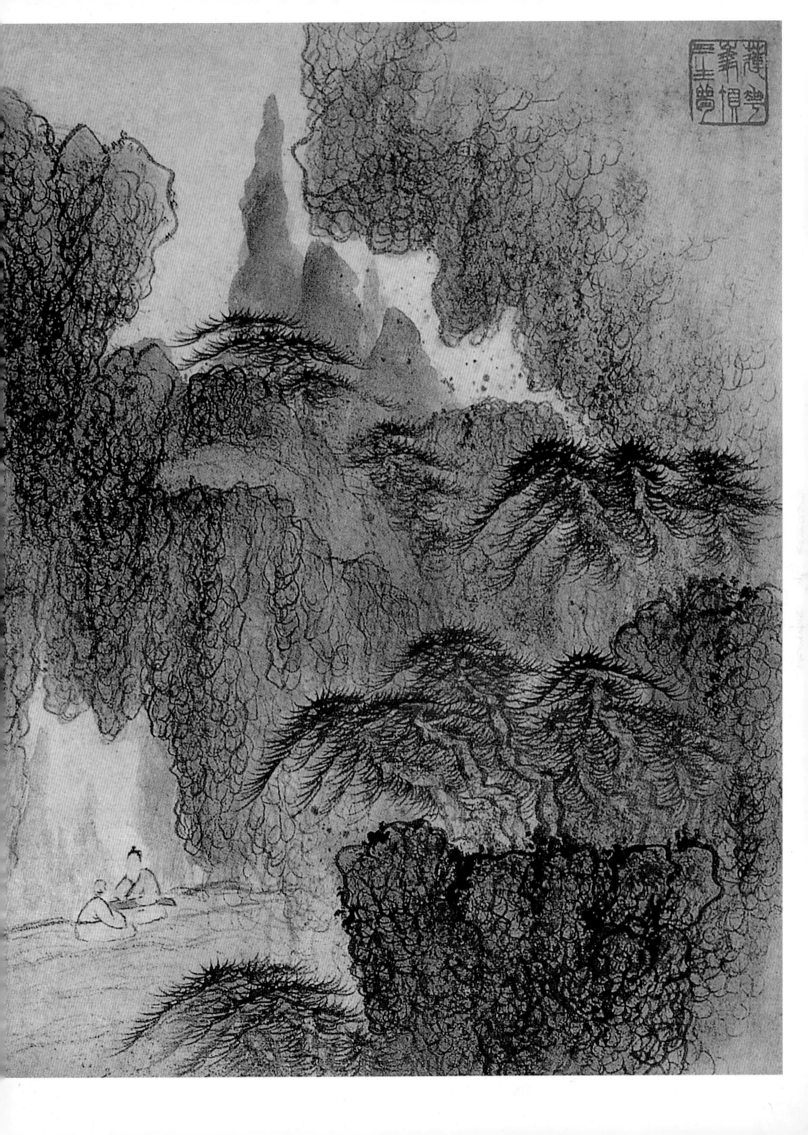

清代 · 畫論

山川之存於外者,形也;熟於心者,神也。神熟於心,此心練之也。心者手之率,手者心之用。心之所熟,使手爲之,敢不應手?故練者非徒手練也,心使練之也。

山水不出筆墨情景,情景者境界也。古云:"境能奪人。"又云:"筆能奪境。"終不如筆、境兼奪爲上。蓋筆既精工,墨既煥彩,而境界無情,何以暢觀者之懷?境界入情而筆墨庸弱,何以供高雅之賞鑒?吾故謂筆墨情景,缺一不可,何分先後?

<div align="right">——布顔圖《畫學心法問答》</div>

雲霞蕩胸襟,花竹怡性情,物本無心,何於人事?其所以相感者,必大有妙理。畫家一丘一壑、一草一花,使望者息心,覽者動色,乃爲極構。

或問僕畫法,僕曰:畫有法,畫無定法;無難易,無多寡。嘉陵山水,李思訓期月而成,吳道子一夕而就,同臻其妙,不以難易別也。李範筆墨稠密,王米筆墨疏落,各極其趣,不以多寡論也。畫法之妙,人各意會而造其境,故無定法也。

畫法須辨得高下。高下之際。得失在焉。筆墨疏落,各極其趣,不以多寡論也。畫法之妙,人各意會而造其境,故無定法也。

畫不尚形似,須作活語參解。如冠不可巾,衣不可裳,履不可屬,亭不可堂,牖不可户,此物理所定,而不可相假者。古人謂不尚形似,乃形之不足,而務肖其神明也。

<div align="right">——方薰《山静居畫論》</div>

墨著縑素,籠統一片,是爲死墨。濃淡分明,便是活墨。死墨無彩,活墨有光,不得不亟爲辨也。

天下之物不外形色而已,既以筆取形,自當以墨取色,故畫之色非丹鉛青絳之謂,乃在濃淡明晦之間,能得其道,則情態於此見,遠近於此分,精神於此發越,景物於此鮮妍。所謂氣韵生動者,實賴用墨得法,令光彩曄,然也。

<div align="right">——沈宗騫《芥舟學畫編》</div>

筆不可窮,眼不可窮,耳不可窮,腹不可窮。筆無轉運曰筆窮,眼不擴充曰眼窮,耳聞淺近曰耳窮,腹無醖釀曰腹窮。以是四窮,心無專主,手無把握,焉能入門?博覽多聞,功深學粹,庶幾到古人地位。

<div align="right">——董棨《養素居畫學鈎深》</div>

王右丞曰:"畫道之中,水墨爲上。"上與尚同,非上下之上。後人誤會,竟認水墨爲上品,著色爲下品矣。…… 或問余曰:"墨畫與著色孰難?"答曰:"余筆蘸墨落紙時,當爲青、黄、赤、白之色;及筆蘸色時,又當爲墨揮灑之而已。"

<div align="right">——張式《畫譚》</div>

作畫須先立意,若先不能立意而遽然下筆,則胸無主宰,手心相錯,斷無足取。夫意者筆之意也。先立其意而後落筆,所謂意在筆先也。

<div align="right">——鄭績《夢幻居畫學簡明》</div>

畫分時代,一見可知,大抵愈古愈拙,愈古愈厚,漸近則漸巧薄矣。嘗見唐人突出紙上,著色濃厚,致絹本已壞,而完處色仍如新。知古人精神遠過近人,此時代爲之,不可强也。且古人恒思傳諸千百年,今人祇求悦庸平人之耳目,其命意亦有不同者。

宋畫易辨,其用意構思,斷非後人所能及,用筆精微神妙,巨眼自能識別……

<div align="right">——華翼綸《畫説》</div>

QING DYNASTY: ARTISTS ON PAINTING

The external existence of mountains and rivers is a matter of form; the familiar imprint left upon the heart is a matter of spirit. The reason that spirit is familiar to the heart is because the heart has rehearsed it. The heart is led by the hand and the hand is used by the heart. What the heart is familiar with, the hand performs. The heart cannot but respond to the hand. Therefore, practice is not just manual practice; it is the heart that makes the hand practice.

Landscape painting is none other than the feelings and scenes expressed through the artist's brush pen and ink. Feelings and scenes create realms. In ancient time, it was said: "Realms can charm people." It was also said: "The brush pen can captivate realms." Still, best of all is for both brush pen and realm to be captivating. If the brushwork is skillful and the inkwork is brilliant, but the realm shows no feelings, the viewer can never be moved. If the realm is filled with feeling, but the brushwork and inkwork are weak, where will you find elegance to appreciate? So I say none of the above, brushwork and inkwork or feelings and scenes can be lacking. So why should there be any ranking as to which is more important?

--"Questions and Answers of Teachings on Painting" by Bu Yantu

Clouds and sunsets stir my heart; flowers and bamboo please my disposition. But things have no intentions, so why do they affect us? There must be subtle reasons why we are affected. When every hill, every valley, every weed and every flower painted by an artist can stir or calm the emotions of the viewer, we have the very best of art.

When someone asks me about the ways of painting, I say: There are ways of painting, but there is no set way of painting; they are not distinguished by difficulty or ease, nor by their number. Li Sixun finished painting his Jialing River landscape in a month, but Wu Daozi accomplished it in one evening. Both attained its wonder, and they cannot be distinguished by degree of difficulty or ease. Li Cheng and Fan Kuan used dense and thick brushwork and inkwork, but Wang Wei and Mi Yuanzhang used sparse and light brushwork and inkwork. Each attained extreme exquisiteness, and their ways cannot be discussed in terms of more or less. The true wonder of ways of painting is that each artist can attune in his own way and create his own realms. Therefore there are no set ways.

One must be able to distinguish between higher and lower qualities among the ways of painting; whether one will succeed or fail is determined by this. Sweet and familiar is not natural; frivolous is not moving; flighty is not refined; crudeness is not vigour; clumsiness is not elegant simplicity; and unsightly strangeness is not amazing.

We should understand the adage that "painting should not emphasize likeness of form" as vital words. Just as "hat" does not refer only to a "cap", and "clothing" does not mean only "gown", "shoes" are not just "sandals", a "pavilion" is not a "hall", and a "portal" is not just a "door". These objects are determined by their inherent nature and usage and they are not interchangeable. When the ancients said that we should not emphasize likeness of form, it was because they were not yet very good at capturing form, so they sought to capture spirit instead.

-- Discussions On Painting from the Quiet Mountain Abode, by Fang Xun

When ink falls onto paper and makes a blob, that is called dead ink. When dense and pale are clearly distinguishable, it is called live ink. Dead ink has no lustre; live ink will glow. One must distinguish between them.

All things are composed of form and colour; therefore the brush pen captures form and the ink captures colour. The colour here does not refer to red, blue or green; it refers to the density and brightness of ink. If an artist can master this principle, then the mood of his painting will be seen, distance will be discernible, spirit will be brilliant, and objects painted will be fresh and beautiful. Liveliness of style is really determined by whether the artist uses ink in such a way that the painting will be bright. That's all.

--*Compilation on Learning to Paint*, by Shen Zongqian

The brush pen should not be lacking, the eyes should not be lacking, ears should not be lacking and the brain should not be lacking. When the brush pen is lacking in variety of movements, it is called "brush pen impoverished". When vision is not extended far and wide, it is called "eyes impoverished". When the ears only hear what is nearby, it is called "ears impoverished". When there is not very much content in the brain, it is called "brain impoverished". With these four impoverishments, the heart cannot concentrate and the hand will lack assurance. How can anyone learn even the fundamentals of painting this way? An artist should view broadly, listen widely, learn more and hone skills until they approach the level of the ancients.

--*Profound Subjects on Learning to Paint from the Studio for Cultivating Simplicity*, by Dong Qi

Wang Wei said: "Among the ways of painting, ink wash painting is supreme." When he said "supreme", he meant "most honoured" and not that ink wash is superior to the other ways. People later misunderstood him by thinking that ink wash paintings are actually superior works, meaning that paintings with colour are inferior works. Someone asked me: "Which is more difficult to paint, ink or coloured paintings?" I answered: "When I soak my brush pen with black ink and I put it to paper, I see it as green, yellow, red or white. When my brush pen is soaked with colour, I brandish it as if it were black ink."

--*Chats on Painting*, by Zhang Shi

To create a painting, one must first establish a concept. Otherwise, if he suddenly starts to paint without a concept in mind, then no one is in charge of the painting, and hand and heart cannot be coordinated, and there is absolutely nothing to be gained by this. The conception refers to the intention of the brush pen. The principle of first establishing the concept then applying the brush pen is called "concept precedes brush".

--*Outline of Learning to Paint from the Fantasy Abode*, by Zheng Ji

It is easy to divide painting into different eras. Generally speaking, the more ancient, the more unsophisticated; the more ancient, the more profound. The more recent, the more clever and flimsy. I have seen paintings by Tang Dynasty artists that leap out of the paper with their thick colours. Even when the silk album has worn out, the colour on the remaining part is just like new. We can see that the spirit of the ancient artists far exceeds that of more recent ones. This is determined by the spirit of the times and cannot be forcibly imitated. Furthermore, ancient artists planned to hand down their works for hundreds or thousands of years, while more recent artists are satisfied with merely pleasing the eyes of ordinary people today. Their standards for selecting themes are also different.

Song Dynasty paintings are easily distinguishable. Their conceptualization and composition are something that later generations cannot aspire to match, and the refinement and exquisiteness of their brushwork is something that anyone with eyes can discern.

--*Talking about Paintings*, by Hua Yilun

圖書在版編目（ＣＩＰ）數據

中國名家繪畫．清代卷．I／況達主編．－北京：
中國書店，2010.11
ISBN 978－7－80663－805－7
Ⅰ.①中… Ⅱ.①況… Ⅲ.①中國畫－
作品集－中國－清代 Ⅳ.①J222
中國版本圖書館CIP數據核字(2010)第215349號

中國書店：出版發行	**Publisher**: Cathay Bookshop
況　達：主編	**Editor-in-Chief**: Kuang Da
Yvonne Li Walls　Jan W. Walls：主譯	**Chief Translators**: Jan W. Walls　Yvonne Li Walls
朱　巖：總監制	**Supervisor**: Zhu Yan
Jan W. Walls：副主編	**Associate Editor**: Jan W. Walls
北京歐亞現代藝術中心(有限公司)：設計制作	**Design**: Beijing Euroasian Modern Arts Center Co., Ltd.
辛　迪：責任編輯	**Managing Editor**: Xin Di
Lucy Jiang　髙艷　應安娜：編輯	**Editors**: Ying Anna　Fanny Gao　Lucy Jiang
董雙全：法律顧問	**Legal Adviser**: Dong Shuangquan
應安娜　Yvonne Li Walls　Jan W. Walls：校對	**Proofreaders**: Jan W. Walls　Yvonne Li Walls　Ying Anna
髙艷　Lucy Jiang：編務	**Editorial Staff**: Lucy Jiang　Fanny Gao
新華書店：經銷	**Marketing**: Xin Hua Bookstore
北京歐亞現代藝術中心(有限公司)	Beijing Euroasian Modern Arts Center Co., Ltd.
2010年11月第1版　第1次印刷：版次	**First Edition**: November 2010
635mm×965mm 1/8：開本	**Format**: 635mm×965mm 1/8
4：印張	**Impression**: 4
ISBN 978－7－80663－805－7	ISBN 978-7-80663-805-7
499.00圓(本輯10冊)：定價	￥499.00 (10 Volumes)